Ten Drawings by Leonardo da Vinci

Published by
Royal Collection Enterprises Limited, St James's Palace, London SW1A 1JR

For a complete catalogue of current publications, please write to the address above,
or visit our website on www.royal.gov.uk

ISBN 1 902163 35 4
British Library Cataloguing in Publication Data
A catalogue record for this book is available from the British Library.

Typeset in Electra and Bauer Bodoni
Designed by Sally McIntosh
Produced by Book Production Consultants plc, Cambridge
Printed and bound by Conti Tipocolor

This publication accompanies the Royal Collection travelling exhibition which will be shown at
the following venues in 2002:
The Lady Lever Art Gallery, Port Sunlight, National Museums and Galleries on Merseyside (15 February – 21 April)
Glynn Vivian Art Gallery, City and County of Swansea (27 April – 7 July)
Graves Art Gallery, Sheffield Galleries & Museums Trust (13 July – 21 September)
Ulster Museum, Belfast, Museums & Galleries of Northern Ireland (27 September – 8 December)

Cover: Leonardo da Vinci, *Neptune* (cat. 5, enlarged detail)
Page 4: Leonardo da Vinci, *A tempest* (cat. 10, enlarged detail)

Ten Drawings by Leonardo da Vinci

A Golden Jubilee Celebration

Martin Clayton

The Royal Collection

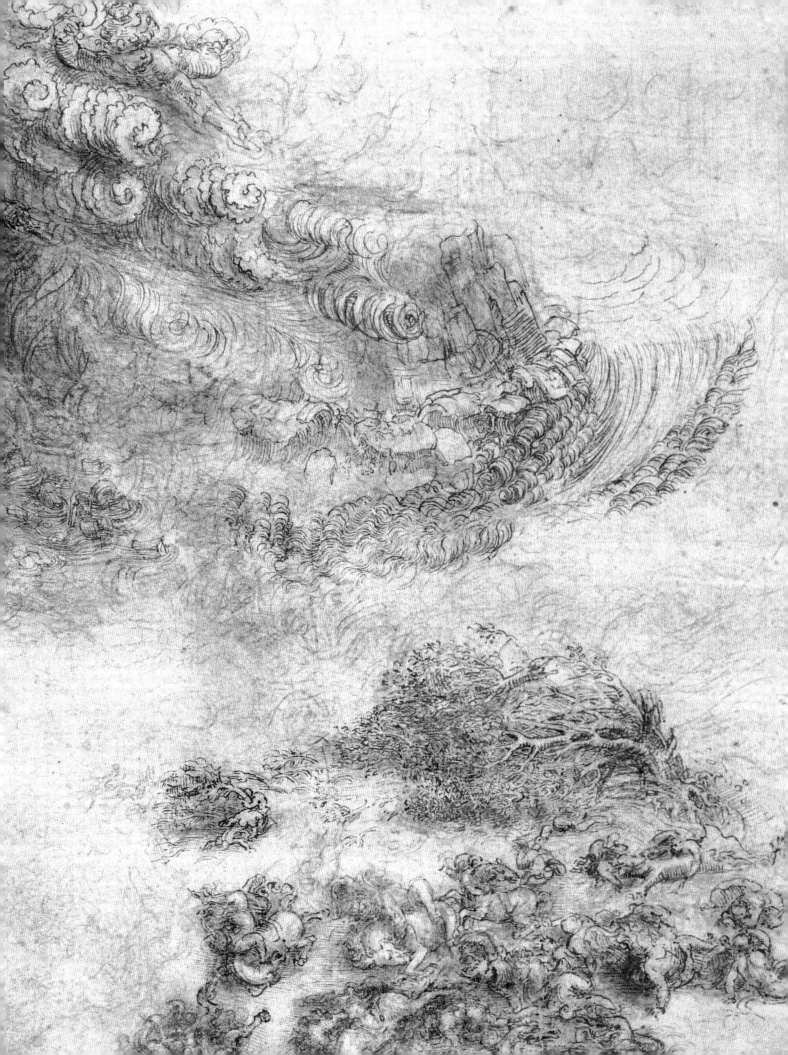

ST. JAMES'S PALACE
LONDON SW1A 1BS

I cannot think of a more appropriate way for the Royal Collection to celebrate The Queen's Golden Jubilee, in what is the 550th anniversary year of Leonardo's birth, than with this exhibition of some of Leonardo's finest drawings from the Library at Windsor Castle.

As Martin Clayton explains in his introduction, *"Ten Drawings by Leonardo da Vinci"* provides a window into the world of one of the most fascinating, technically brilliant and intellectually stimulating artists of any age. Of Leonardo, perhaps more than any other artist, it can, truthfully, be said that "all human life is there", and even this small selection of his drawings shows the "infinite variety" of his talent and of his mind, from his intimate studies of the human anatomy, to his exploration of the power and pent-up energy of the forces of nature. The human experience is laid before us in Leonardo's drawings and that is perhaps why he still speaks so strongly to us today.

I am delighted that, like the *"Ten Religious Masterpieces"* exhibition for the millennium, these drawings will, in Golden Jubilee year, be laid before the widest possible public in galleries way beyond the capital. The Queen and the Trustees of the Royal Collection remain determined that such fine examples of the collection of drawings from Windsor should be seen by as many people as possible. I am sure that everyone who visits this exhibition will be as inspired as I have always been by Leonardo's genius and skill.

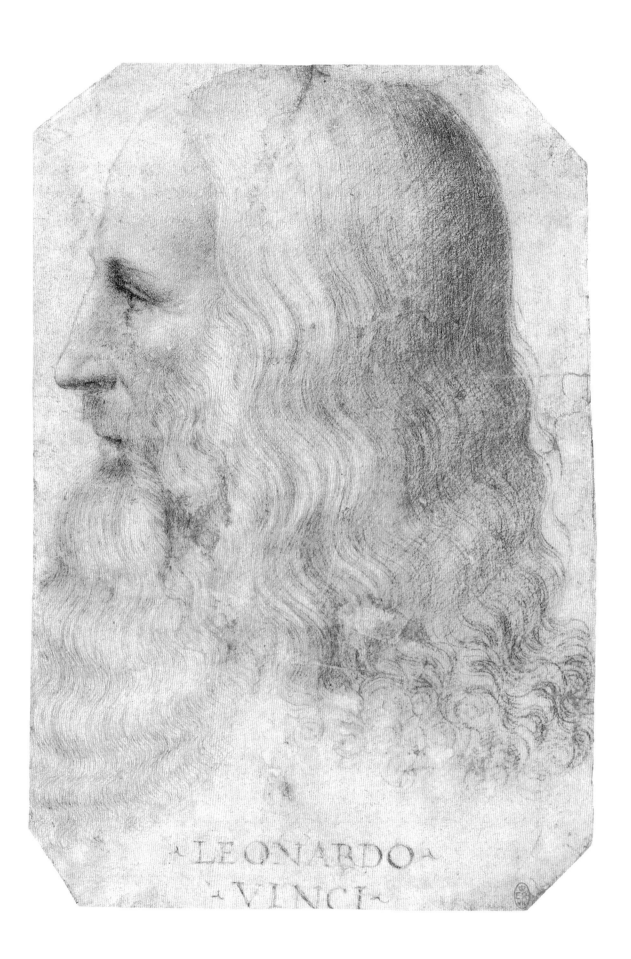

Introduction

Leonardo da Vinci (1452–1519; fig. 1) was the archetypal 'Renaissance man', accomplished in painting, sculpture, architecture, music, anatomy, engineering, cartography, geology and botany. Yet beyond a handful of paintings, and a memory of the great projects that failed to reach completion, the extent of his achievements was little known to his contemporaries and successors. Leonardo's surviving notebooks were not transcribed and published until the late nineteenth century, and research has enabled his many hundreds of drawings to be properly understood only within the last few decades.

Leonardo's drawings are the richest, most wide-ranging, most technically brilliant and most endlessly fascinating of any artist. Only a small proportion are connected directly with his paintings or sculpture projects. The remainder were Leonardo's attempt to record and explain the infinite variety of experience – the theme of his whole career; and, although he developed a rich and powerful literary style, Leonardo maintained that an image transmitted knowledge more accurately and more concisely than words. In his drawings, therefore, we can follow the development of an intellectual fertility unmatched in the history of Western thought.

LEONARDO'S YOUTH (1452–1481)

Leonardo was born on 15 April 1452 near the town of Vinci, fifteen miles west of Florence in the Arno valley. He was the illegitimate son of a notary, Ser Piero da Vinci, and a peasant girl named Caterina, and was taken into his paternal grandfather's house. We have no idea of the nature of Leonardo's education, other than that he learned to read and write. Leonardo was left-handed, and throughout his life he wrote his notes in mirror-image, from right to left (though he could easily write conventionally when necessary – see cat. 3). This was not an attempt to keep his researches secret, as has been claimed, for Leonardo's writing is relatively easy to read with a little practice. Mirror-writing is a common developmental quirk in child-hood, and what may have begun as an entertaining trick became a habit that Leonardo never had any cause to discard.

By 1472, at the age of twenty, Leonardo was a fully-fledged artist in Florence. He had joined the painters' guild, the Company of St Luke, and (though his presence there is not

Fig. 1
Attributed to Francesco Melzi
A Portrait of Leonardo, c.1515
Red chalk, 275 × 190mm (10¹³⁄₁₆ × 7½")
RL 12726

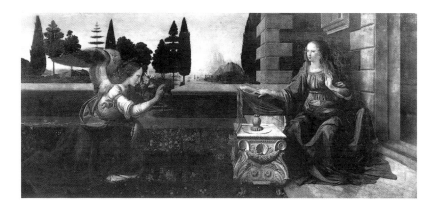

Fig. 2
Leonardo da Vinci
*The Annunciation, c.*1472–4
Tempera and oil on panel
98 × 217cm (38½ × 85½")
Florence, Uffizi

documented until 1476) was probably working in the studio of the sculptor and painter Andrea del Verrocchio (died 1488). Leonardo seems to have exercised his right as a member of the guild to accept contracts in his own name, while still putting his hand to products of Verrocchio's studio. Paintings such as the *Annunciation* (Florence, Uffizi; fig. 2), the *Madonna with the Carnation* (Munich, Alte Pinakothek) and the portrait of *Ginevra de' Benci* (Washington, National Gallery of Art), which are entirely by Leonardo, all seem on grounds of style to have been executed earlier than his contribution to the *Baptism of Christ* (Uffizi), a collaborative work of Verrocchio's studio.

Leonardo's early drawings were little different in type from those of his contemporaries in the studio – compositional sketches, studies of details for paintings and drawing exercises. The two principal drawing media of his youth were metalpoint and pen and ink. Metalpoint makes use of the fact that when a metal stylus (usually of silver) is drawn over the surface of a sheet of paper coated with a preparation of finely ground bone, it leaves an extremely thin layer of the metal which oxidizes immediately to give a dark grey trace. Varying the pressure on the stylus does not change the character of the line, and the mark cannot be erased. Metalpoint thus demands control and discipline, and was the standard medium for the training of young artists in fifteenth-century Italy. Leonardo used metalpoint mainly for careful drawings from the life (cat. 1); the looser medium of pen and ink was generally reserved for sketches from the imagination.

The last work of Leonardo's early Florentine period was the *Adoration of the Magi* (Uffizi, fig. 3), commissioned in March 1481 by the monks of San Donato a Scopeto outside Florence. In September of that year Leonardo took delivery of a barrel of wine as part payment for the work, but the painting remained unfinished. Nothing is known of Leonardo's activities for the next eighteen months.

Fig. 3
Leonardo da Vinci
*The Adoration of
the Magi*, 1481
Oil on panel
246 × 243cm (97 × 96")
Florence, Uffizi

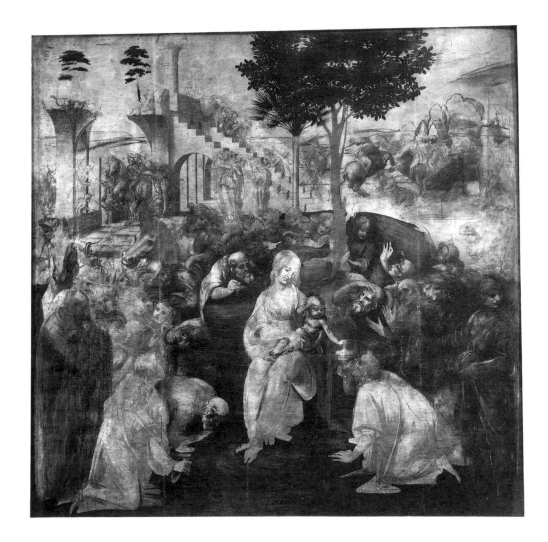

A COURT ARTIST IN MILAN (1483–1499)

Leonardo had settled in Milan by April 1483, when he received the commission for an altarpiece for the church of San Francesco Grande (cat. 2). He was to remain in Milan for seventeen years, his longest continuous period in any one city, and at some point during the 1480s he entered the service of Ludovico Sforza, effective ruler of Milan. The main reason for this employment was probably a projected bronze equestrian monument to Ludovico's father (cat. 1), but as a court artist Leonardo also executed portraits and other paintings, and made designs for architecture and for entertainments. As work on the Sforza monument ground to a halt in the mid-1490s Leonardo began his greatest finished painting, the mural of the *Last Supper* in the refectory of Santa Maria delle Grazie (fig. 4).

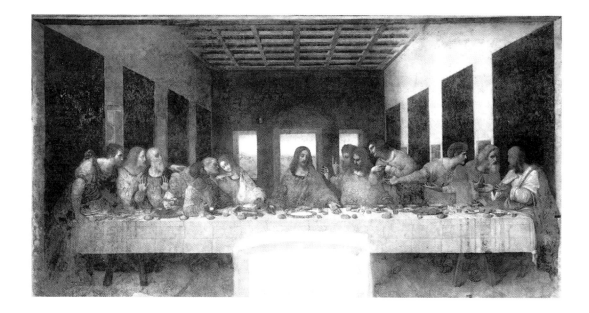

The greatest single development in Leonardo's draftsmanship occurred in the early 1490s, when he began to exploit natural red and black chalks as drawing media. While red chalk (a red-ochre variety of haematite) and black chalk (a soft carbonaceous schist) had both been available in Verrocchio's studio while Leonardo was working there in the 1470s, he had taken little advantage of their tonal possibilities. But around 1492 chalks suddenly supplanted metalpoint in Leonardo's drawings, and from then onwards he was to use the media in every manner conceivable: for the most rapid sketches, for heavily worked compositional studies (cat. 5), for smoky studies of form rubbed and accented with sharp lines, and for intricately modelled drawings using the point of the chalk only (cat. 6). Leonardo made many of his chalk drawings on coloured grounds, preparing his paper with a pale red wash for red chalk drawings (cat. 6 and 8). His purpose in so doing is uncertain, but by deliberately restricting the available tonal range Leonardo was able to explore the most subtle effects of modelling.

Leonardo's first period in Milan also saw the expansion of his interests into scientific matters. He assembled a small technical library and taught himself some Latin, in which nearly all treatises were written. Combining received wisdom with personal experience, Leonardo began to record observations on anatomy (fig. 5), proportion, light and colour, perspective and optics, dynamics and statics. Many of these notes were conceived as contributions to projected treatises on painting (cat. 7) and on the human body (cat. 9), works that Leonardo long planned but never realised in a final form.

Fig. 4 *(opposite)*
Leonardo da Vinci
The Last Supper (before
restoration), *c.*1495–8
Tempera and oil on plaster
460 × 880cm (180 × 350″)
Milan, Santa Maria delle
Grazie

Fig. 5
Leonardo da Vinci
*A skull bisected and
sectioned* (detail), 1489
Pen and ink, whole sheet
190 × 137mm (7½ × 5⅜″)
RL 19058v

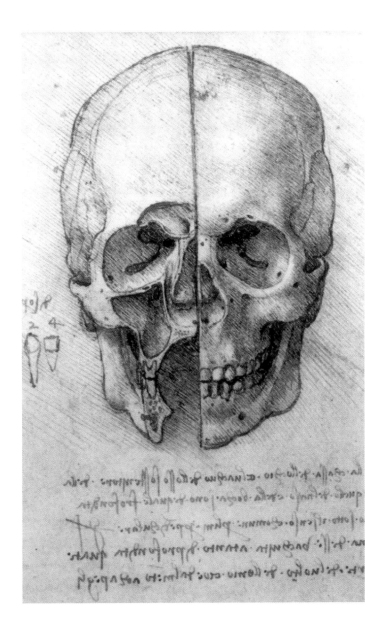

A New Century – Mainly in Florence (1500–1508)

In 1499, French forces under Louis XII invaded Lombardy and occupied Milan, deposing Leonardo's patron Ludovico Sforza. Leonardo soon left the city, travelling to Venice for a short time before settling again in Florence. His first works back in the city of his youth were apparently the so-called *Madonna of the Yarnwinder* (known in two versions in private collections) and a cartoon of the *Madonna and Child with St Anne and a lamb*; but a contemporary reported that Leonardo was preoccupied with geometry and was 'very impatient with the brush'. This impatience deprived Leonardo of a reliable income, and in the summer of 1502, at the age of fifty, he joined the entourage of Cesare Borgia (1476–1507). As Marshal of the Papal Troops, Cesare (an illegitimate son of Pope Alexander VI) was at this time rapidly

reclaiming papal territory in Romagna and the Marches to the east of the Florentine state, through a combination of diplomacy and ruthless warfare. For nine months Leonardo toured Romagna and the Marches, visiting Cesena, Rimini, Urbino, Pesaro and Imola, surveying fortifications and probably directing improvements to them.

Leonardo's work for Cesare may have been cut short in 1503 by his receipt of a commission from the Florentine government to paint a huge mural, the *Battle of Anghiari*, in the council chamber of the Republic. Although the *Battle* was the most prestigious commission of his career, and was planned in direct competition with a pendant work by Michelangelo for the same hall, Leonardo continued to be diverted into other projects. Among other paintings he probably began work on the *Mona Lisa* (Paris, Louvre) and *Leda and the Swan* (destroyed; see cat. 6), and he made a finished drawing of *Neptune* (cat. 5). He compiled manuscripts on the flight of birds and stereometry (the geometry of solids), and his engineering skills were called upon several times by the Republic: he surveyed the Arno near Florence, he was consulted about a scheme to divert the river at Pisa, and he advised on fortifications at Piombino, on the coast south of Livorno (see also cat. 3).

In May 1506 Leonardo obtained leave to return to Milan for three months. This marked the start of an unsettled two years for the artist, during which he travelled between Florence and Milan at least five times. The *Battle of Anghiari* fell into abeyance and was never

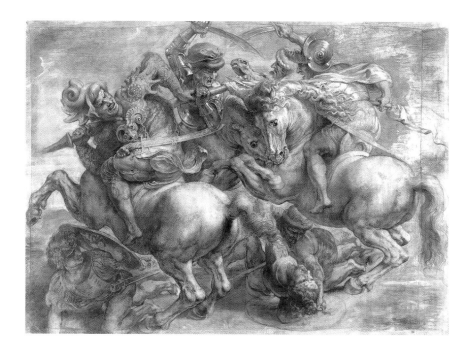

Fig. 6
Attributed to Peter Paul Rubens,
after Leonardo da Vinci
The Battle of Anghiari, c.1612–15
Black chalk, pen and ink, wash,
white and grey bodycolour
452 × 637mm (17¹³⁄₁₆ × 25¹⁄₁₆")
Paris, Louvre

finished; it is known today only from more or less accurate copies (fig. 6). Leonardo instead occupied himself with intermittent work on easel paintings and a return to the study of human anatomy. In the winter of 1507–8 he performed an autopsy on an old man in the hospital of Santa Maria Nuova in Florence; the resulting drawings are the most extensive record of a single dissection by Leonardo to survive, and this was to be the basis of his greatest achievements in anatomy, after his decisive return to Milan around Easter 1508.

The Last Years (1508–1519)

Leonardo lived in or near Milan for the next five years. During this time he probably began work on the *Madonna and Child with St Anne and a lamb* (Louvre; fig. 7), but painting seems to have occupied him little. Instead he planned a villa for the French governor of Milan, advised on watercourses, surveyed the valleys north of Bergamo, and was consulted on a project for choir stalls in Milan Cathedral. Of most interest to him were his scientific pursuits, especially anatomy and the motion of water, and many hundreds of drawings of these subjects date from this time (cat. 9). But once again political and military affairs disrupted Leonardo's work: Swiss forces employed by both the Pope and the Holy Roman Emperor captured part of the city of Milan in July 1512, although the French managed to hold the citadel, the Castello Sforzesco, for another year. Artistic activity was stifled by the impossibly volatile situation, and in September 1513 Leonardo and four assistants once more left Milan.

For the next three years Leonardo was based in Rome, at first under the patronage of Giuliano de' Medici, brother of the recently elected Pope Leo X. During the previous five years Rome had become the centre of the High Renaissance, with Michelangelo's Sistine Chapel ceiling frescoes newly unveiled and Raphael at work in the Vatican Stanze, but Leonardo's artistic activities in the city are hard to define. He made frequent extended trips away from the city, to Civitavecchia and Parma in 1514, and to Florence and Milan in 1515, and it appears that, now aged over sixty, he was painting less and less.

Drawing continued to be the major outlet of Leonardo's creativity, and the decade before his death in 1519 is marked by an increasingly experimental approach and a highly inventive manipulation of all available media. Leonardo mixed black, red and occasionally white chalks on a red ground to give a richness to studies of hair (cat. 8) or to atmospheric landscapes. In the very last years of his life, he purged his drawings of much of their colour, restricting his materials to black chalk, pen and ink, and wash; the black chalk underdrawing was given an increasingly important role in modulating tonality, and drawings such as cat. 10 exploit the three media in complementary roles to achieve effects of great depth and richness.

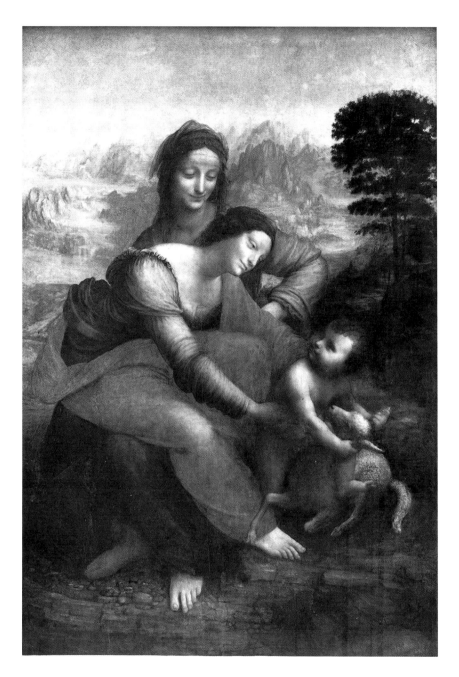

Fig. 7
Leonardo da Vinci
*The Madonna and Child
with St Anne and a lamb,*
*c.*1508–19
Oil on panel
168 × 130cm (66 × 51")
Paris, Louvre

The last two-and-a-half years of Leonardo's life were spent in the Loire valley in central France, at the court of King Francis I. The French had been well aware of Leonardo's talents since their occupation of Milan in 1499, and his works had been sought by a succession of French patrons. Leonardo's virtuosity had been brought directly to the attention of Francis I by his design of a mechanical lion, commissioned by the Florentine community in Lyons to welcome the king into that city in July 1515. Our last record of Leonardo's presence in Rome is dated August 1516, and by January 1517 he was at Romorantin (between Orléans and Bourges in central France), planning a canal.

Fig. 8
Leonardo da Vinci
A costume design for an
*entertainment, c.*1517–18
Black chalk, pen and ink, wash
273 × 183mm (10¾ × 7³⁄₁₆")
RL 12575

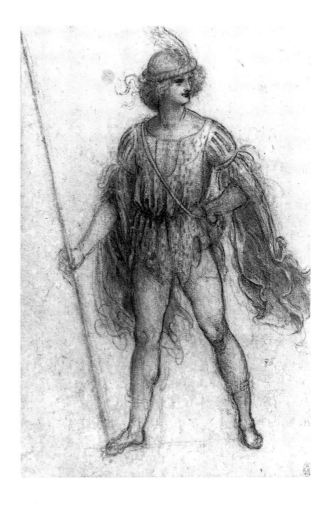

Leonardo settled at Amboise, one of the chain of royal residences in the Loire valley, where he held a privileged position as First Painter, Engineer and Architect to the King. He earned his keep by advising on architectural and engineering matters, by providing designs for entertainments (fig. 8), and by being entertaining himself: some years later, Benvenuto Cellini reported that Francis I 'took such pleasure in hearing [Leonardo] talk that he would only on a few days of the year deprive himself of his company'. In these last years Leonardo seems to have painted little, if at all, and his faithful companions Salai (see cat. 8) and Francesco Melzi probably acted as the executants of his designs. After two of the most gratifying years of his life, Leonardo died on 2 May 1519.

From Amboise to Windsor: the Provenance of Leonardo's Drawings

All the drawings and manuscripts in Leonardo's studio at his death were bequeathed to his pupil Francesco Melzi, who took them back to his family villa near Milan and tried to put them in some sort of order. Melzi numbered many of the drawings in sequences according to their subject matter (his numbers are seen on five of the sheets here), and transcribed passages from Leonardo's writings in an attempt to compile the *Treatise on Painting* that the

Fig. 9
The binding of the Leoni
volume at Windsor, *c.*1590–1600
Leather, 470 × 330 × 65mm
(18½ × 13 × 2⁹⁄₁₆")
RL 33320

artist himself never completed. On Melzi's death, around 1570, his son sold Leonardo's papers to the sculptor and collector Pompeo Leoni, who pasted the loose drawings into the pages of several albums, of which two survive: the Codex Atlanticus, now in the Biblioteca Ambrosiana in Milan, and the volume that contained all the drawings now at Windsor (the binding has been preserved as an empty shell, fig. 9).

The future Windsor volume was auctioned after Leoni's death in Madrid in 1608, and somehow found its way to England; there is evidence that it was in the possession of the great collector Thomas Howard, second Earl of Arundel, by 1630. Arundel left England during the Civil War, and it is not known whether he took the Leonardo drawings with him. They are not recorded again until 1690, when they were seen at Kensington Palace in the possession of Queen Mary. The means by which the volume entered the Royal Collection is unknown but it is probable that it was acquired by King Charles II (reigned 1660–85).

The Royal Library, including the collection of Old Master drawings, was moved to Windsor in the 1830s, and most of the Leonardo drawings were removed from the Leoni binding later that century, both for exhibition and to halt abrasion of the chalk drawings caused by turning the pages. In the early 1970s a conservation programme was begun, in which all the Leonardo drawings were lifted from their acidic nineteenth-century mounts and suspended between ultra-violet-filtered perspex sheets. Over the last thirty years the Leonardos have been seen by millions of people in exhibitions held around the world.

The Drawings

*c.*1490
Metalpoint on pale buff prepared paper
200 × 284mm (7⅞ × 11³⁄₁₆")
Inscribed lower centre .48.
RL 12317

In the years around 1490 Leonardo made many studies of horses in the ducal stables in Milan. Some were systematic surveys of their measurements, others were sketches capturing casual poses. Cat. 1 is the most substantial of these drawings from the life. The outlines were decisively laid in with the metalpoint stylus and areas were shaded in with rapid hatching, giving a wonderful sense of lively bulk.

All these drawings of horses were studies for a projected equestrian monument to Francesco Sforza, the former Duke of Milan, who had died in 1466. The project is first mentioned in a letter of November 1473 from his son Galeazzo Maria to the commissar of the ducal works, instructing him to find an artist capable of executing such a monument. Apparently nothing was done at this time; Galeazzo Maria was murdered in 1476, and his brother Ludovico, the presumptive Duke of Milan, went into exile until 1479. Some years after his return, Ludovico revived the project and began looking again for a suitable artist. In a draft of a letter to Ludovico seeking a position at court, Leonardo stated: 'The bronze horse may be taken in hand, which is to be to the immortal glory and eternal honour of the prince your father of happy memory, and of the illustrious house of Sforza.'

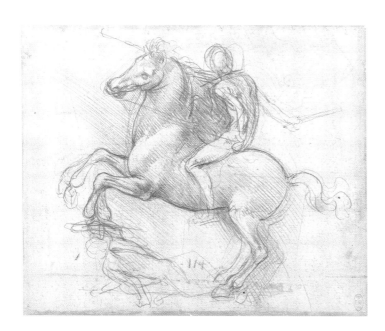

Fig. 10
Leonardo da Vinci
A *design for the Sforza monument*, *c.*1488–90
Metalpoint on blue prepared paper
148 × 185mm (5¹³⁄₁₆ × 7⁵⁄₁₆")
RL 12358

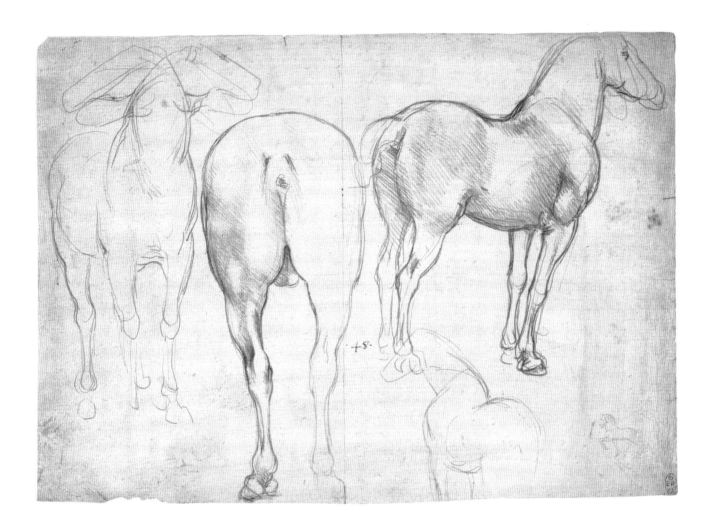

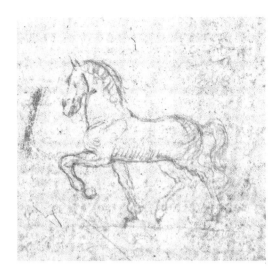

Detail of cat. 1

Leonardo's bid for the commission was successful. His early designs for the monument show the horse rearing, its forelegs supported either by a tree-stump or by a cowering soldier (fig. 10). But bronze casting was technically very difficult, and, although he had trained in the studio of Andrea del Verrocchio, Italy's most accomplished sculptor in bronze in the 1470s, there were doubts that Leonardo would be capable of completing such a piece. In the summer of 1489 the Florentine ambassador in Milan wrote to Lorenzo de' Medici requesting the names of other artists who might be more suitable, and two finished studies for a monument by Antonio Pollaiuolo (New York, Metropolitan Museum, and Munich, Graphische Sammlung) may date from this stage of the project. Evidently Leonardo overcame the Duke's doubts, however, for on 23 April 1490 he recorded, 'I recommenced the horse.'

At this stage Leonardo changed the conception of the sculpture. He rejected the ambitious rearing pose for a more sober and conventional pacing horse, as shown in the tiny sketch in the lower right corner of cat. 1 (see detail). The proportions of the horse became more monumental, changing from the delicate, skittish type seen in the first designs (and familiar from Leonardo's work on the *Adoration of the Magi* ten years earlier; see fig. 3) to a more classical type with a heavier frame and a noble head, as seen here.

By the autumn of 1493 Leonardo's preparations were complete. He had constructed an enormous clay model, seven metres (24 feet) high, but he never had the chance to cast it. French forces invaded Italy in 1494, and though Ludovico Sforza had an understanding with the French king, Charles VIII, the position of his father-in-law Ercole d'Este in Ferrara was less secure. Ludovico sent the bronze intended for Leonardo's horse to Ferrara to make defensive cannon. In a draft of a letter of the mid- to late 1490s to Ludovico, Leonardo wrote resignedly, 'of the horse I will say nothing, for I know the times'. In 1498 Charles VIII died and was succeeded by Louis XII, who claimed the Duchy of Milan. A year later his forces invaded Lombardy. Ludovico Sforza fled, Leonardo left Milan in December, and his huge clay horse was used for target practice by the French troops and destroyed.

2. The drapery of a kneeling figure

*c.*1491–4
Brush and black ink with white heightening on pale blue prepared paper
213 × 159mm (8⅜ × 6¼")
Inscribed lower centre 223
RL 12521

This is a study for the drapery of the angel in Leonardo's *Virgin of the Rocks* in the National Gallery, London (fig. 11). An earlier version of the painting is in the Louvre in Paris. Both show the Virgin and Child with the infant St John the Baptist and an angel, in a dark and rocky setting that has given the paintings their common name.

While the compositions and poses of the two versions are essentially the same, there are numerous differences of detail. The drapery of the angel in the Paris version isolates the arm and head, and an unbroken area of cloth over the flank exaggerates the posterior of the angel to an unfortunate degree. Here, Leonardo redesigned the drapery completely for the second version, leading a swag of drapery from the right shoulder down over the left hip and thigh to break the expanse of cloth.

The project of the *Virgin of the Rocks* was the most protracted of Leonardo's career, lasting a quarter of a century from first commission to final settlement. Leonardo and the half-brothers Ambrogio and Evangelista de' Predis signed a contract with the Confraternity of the Immaculate Conception on 25 April 1483 to paint an altarpiece of several panels for a chapel in the church of San Francesco Grande, Milan. These panels were apparently complete within a couple of years, though they were not delivered to the Confraternity owing to a dispute over their valuation (and possibly also over the iconography of the central scene). The principal painting from this first phase of the project was then probably sold by the artists in the early 1490s to a third party, and another version of the central panel was begun by Leonardo in collaboration with Ambrogio de' Predis (Evangelista had since died), although less of the painting was carried out by Leonardo than in the first version. This was finally delivered to the Confraternity in 1508 and installed in San Francesco Grande. The painting was sold off in 1785.

It was a common practice in the artists' workshops of renaissance Florence to make drapery studies by drawing with the brush on prepared linen. The sixteenth-century biographer Giorgio Vasari wrote of Leonardo that as a youth

> …he often made figures in clay which he covered with a soft worn linen dipped in plaster, and then set himself to draw them with great patience on a particular kind of fine Rheims cloth or prepared linen; and he executed some of them in black and white with the point of a brush, quite marvellously.

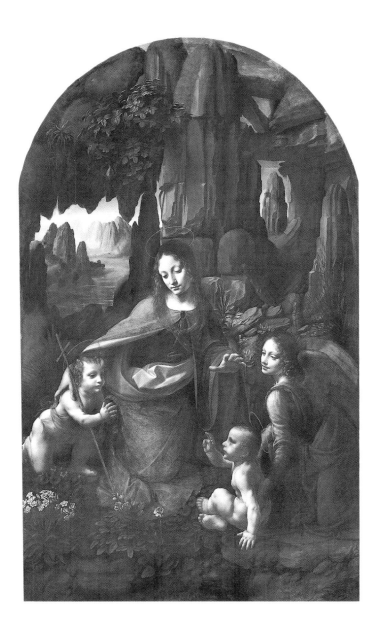

Fig. 11
Leonardo da Vinci
and workshop
The Virgin of the Rocks,
*c.*1490–1508
Oil on panel
189.5 × 120cm (74½ × 47¼")
London, National Gallery

A number of studies in this technique do survive that are reasonably attributable to Leonardo. The present study is in the same manner but the forms are more voluptuous than the rather hard and sometimes sharply angled folds of the early group on cloth. It is drawn on paper rather than linen, and the smoother surface allows one to see the range of Leonardo's brushstrokes, from sweeping outlines and broad shading to meticulously fine hatching and crosshatching in both black and white. The paper was prepared with a single thin layer of pale blue ground to provide a mid-tone that enhances the effect of the white highlights.

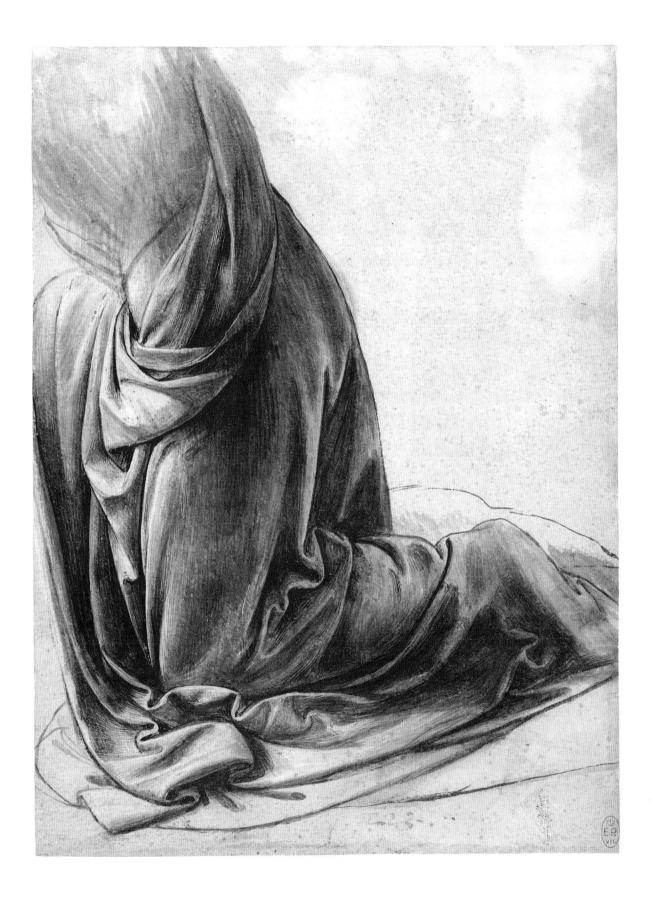

*c.*1503–4
Black chalk underdrawing, pen and ink, watercolour and bodycolour
338 × 488mm (13�5/16 × 19³/16")
Extensively inscribed by Leonardo
RL 12278

This elaborate map centres on the marshy lake, about forty kilometres (twenty-five miles) long, that in Leonardo's time occupied the valley in southern Tuscany known as the Valdichiana. North is to the left. The river Tiber runs along the top edge, with a bend of the Arno at the centre of the left edge. The city of Perugia can be seen at upper right, Arezzo to the upper left and Siena at lower centre.

The layout of the cities and rivers is not particularly accurate, and must have been derived from a pre-existing map; it is quite seriously distorted in the lower part of the sheet, squeezing in Volterra (bottom left), the lake of Bolsena (centre right edge) and even the sea (lower right corner). The Valdichiana itself, however, is meticulously drawn. A sketch-map by Leonardo (Codex Atlanticus, f. 336r) shows in great detail the roads and streams around Castiglione Aretino (now Castiglione Fiorentino) and Montecchio, at the centre of the present sheet (see detail overleaf) with precise distances that must have been paced out by Leonardo. Also at Windsor is a bird's-eye view of the Valdichiana (fig. 12), showing the marshy nature of the northern part of the lake and listing the distances between Castiglione, Foiano and other towns in the vicinity. These distances are crossed through, perhaps indicating that Leonardo referred to them when constructing the present map.

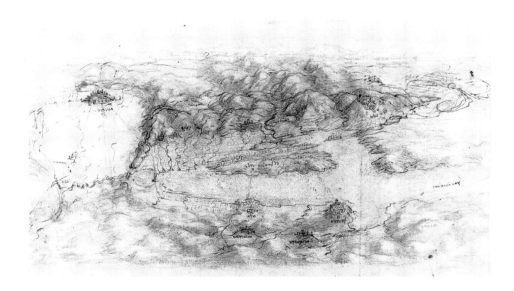

Fig. 12
Leonardo da Vinci
A bird's-eye view of the
Valdichiana (detail), *c.*1503–4
Black chalk, pen and ink, wash
whole sheet 209 × 281mm
(8¼ × 11¹/16")
RL 12682

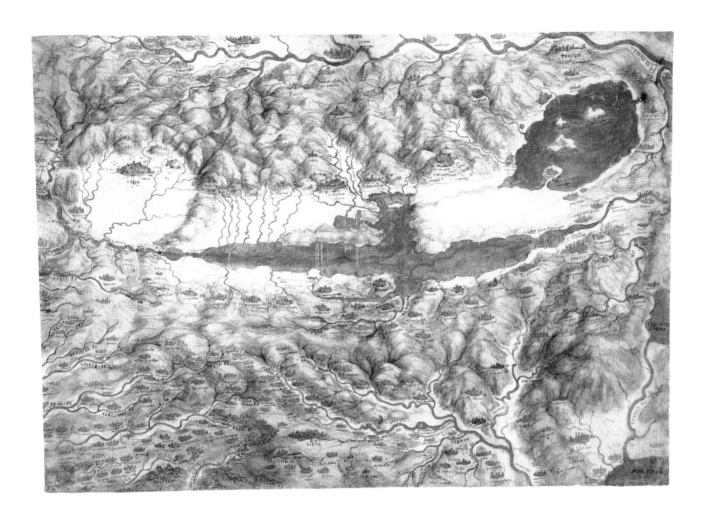

The Valdichiana no longer has the form in which Leonardo drew it. In the Roman period the river Chiana flowed south into the Tiber, but silt from tributaries had by the Middle Ages turned the river into a malarial marsh (which was cited as an exemplar of pestilence by Dante, *Inferno*, XXIX, 46–7). In 1342 the Aretines began to drain the northern part of the marsh nearest to Arezzo, leading the waters northwards to the Arno, and the result is shown here – a large, shallow, marshy lake with issues both north and south. Drainage work proceeded slowly, and it was not until the middle of the sixteenth century that the digging of the Canale Maestro along the length of the marsh began in earnest. Soon the channel ran as far south as the Ponte di Valiano (seen here to the right end of the lake), but a lack of co-operation between the Grand Duchy of Tuscany to the north and the Papal States to the south brought the work to a halt. Over the next two centuries only another five miles of canal was dug, and the Maestro now ends at the Lago di Montepulciano, at the southern end of the Valdichiana, which, like the Lago di Chiusi, was never drained.

Every village and river here is named in conventional left-to-right script, by contrast to Leonardo's habitual mirror-writing, and it can therefore be assumed that the map was made by Leonardo for the use of someone other than himself. At this time the Valdichiana formed the southern limit of Florentine territory, and we know that Leonardo was consulted on several engineering and hydraulic schemes by the Florentine government in 1503 and 1504 – a plan to divert the Arno away from Pisa while the Florentines were besieging it, surveys of the river east and west of Florence, and work on the fortifications at Piombino.

A project to further the draining of the marsh, promoted by the Florentine government, may well have been the context of the present map. Around 1515 Leonardo was involved in just such a scheme in the Pontine marshes south of Rome, and he drew a comparable map of that area, indicating drainage channels to be dug – a project that was carried through between 1515 and 1521 by Fra Giovanni Scotti da Como. Beyond his drawings we have no documentary evidence that Leonardo was involved with any such programme of works in the Valdichiana, but throughout history many more such labour-intensive projects have been mooted than were ever carried out.

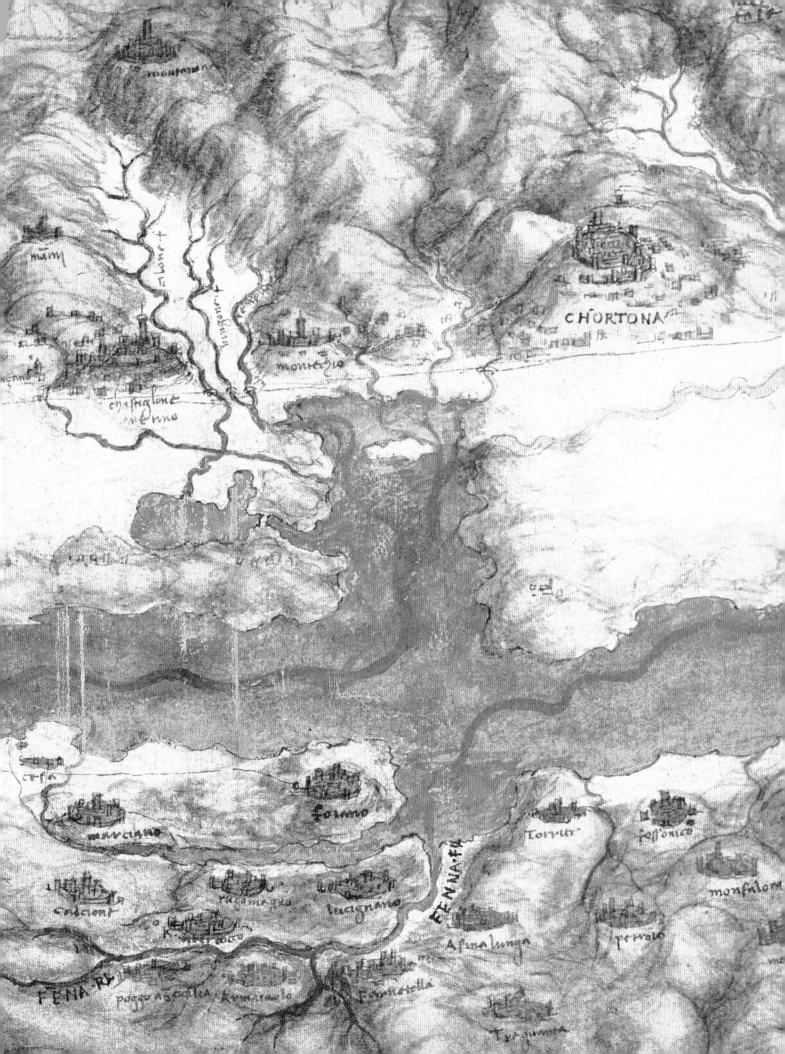

*c.*1503–4

Pen and ink with brown wash over black chalk

329 × 480mm (12 $^{15}/_{16}$ × 18 $^{7}/_{8}$ ")

Inscribed upper left *187*

RL 12275

The rapid development in the use of gunpowder around 1500 led to a radical revision of the theories and practice of warfare and fortification. The tall medieval curtain wall became vulnerable to cannon fire: using this weapon the army of Charles VIII had rapidly breached fortress after fortress in the invasion of Italy in 1494. Military architects soon realised that the most effective defence against cannon was not a high wall but a low, thick rampart, with projections to allow defensive fire in all directions and protected from direct assault by a system of ditches. As the reliability and power of artillery increased during the sixteenth century, so too did the complexity of these walls and of the outworks placed before the bastions.

Leonardo's career spanned these developments. His draft letter to Ludovico Sforza (see page 18) made great play of his skills as a military engineer, which many of his drawings bear out. Leonardo's first surviving notebook, compiled in the later 1480s, contains drawings of architecture and of military devices, and subsequently he made many designs for both the old type of weapon – lances, chariots, enormous catapults and crossbows – and the new – cannon and mortar. He also made theoretical studies of fortifications, some types of which were to become common in the succeeding century (such as geometrically designed bastions), while others were merely 'ideal forms' (such as concentric rings of galleried ramparts with low, sloping profiles).

The present drawing is unusual in that it deals with tactics rather than design. Four mortars fire missiles over a high curtain wall into the courtyard of a fortress, where there are long covered galleries with gun emplacements. Despite Leonardo's obsessive freehand drawing of the missile trajectories, it is the breach in the wall at centre right that is the focus of the drawing. A section of the wall has been demolished and has fallen into the inner moat, and cannon facing into the fortress have been placed on earthworks either side of the breach. The same scheme is found on two other drawings by Leonardo (RL 12337v and Codex Atlanticus f. 24r-a), each with accompanying notes. Further commentary is found on another sheet in the Codex Atlanticus (f. 360v-a), which fully explains what is seen in the present drawing:

> As the defences are overcome throw down [a part of] the wall … . Throw the debris into the moat on the other side of the wall to make a protection against attacks from the opposite side of the moat, which would otherwise cause a great slaughter of men.

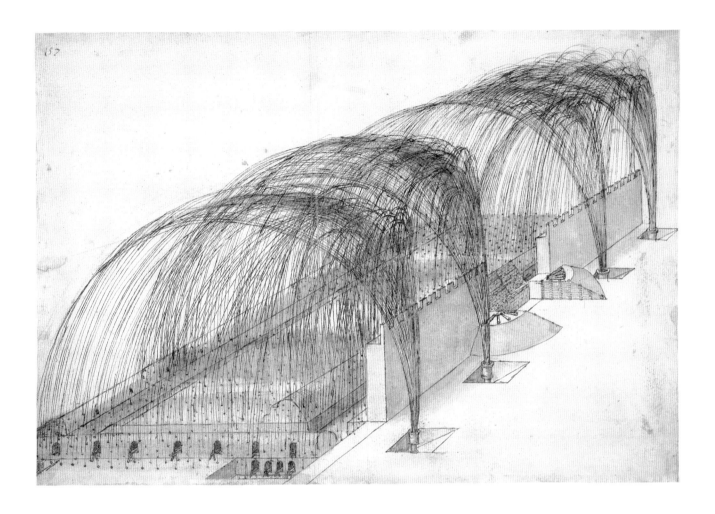

Next to the ends of the remaining walls make two great earthworks of branches, earth and straw, and lean them against the walls, and on top of them place the artillery so that their fire is directed to the face of the inner moat, where the hidden guns are located, that is, the defences which cover the moat by crossfire and which could not be eliminated by the rain of stones from the mortars because they are protected by beams and earth.

An alternative method of dealing with defensive emplacements and mined fortifications is outlined on RL 12337v:

If you do not need the mortars, fill the ditches with water, and as they overflow the water will fill up the other ditches … and thus the defences of the ditches shall have been eliminated, those that the defenders, who are concealed in such ditches, have arranged both frontally and laterally. The water will [also] prevent the fire that the enemy might have planned to set off in the mines by means of a great quantity of timber.

The presence of studies for the *Battle of Anghiari* on both of the sheets RL 12337 and Codex Atlanticus f. 24r-a dates the drawings to 1503–4, after Leonardo's spell as military engineer to Cesare Borgia. He was consulted by the Florentine government on several programmes of works in these years, most relevantly on the fortifications at Piombino in late 1504. But the nature of this drawing suggests that it was a theoretical study of military tactics, of a type that was common throughout the Renaissance, rather than connected directly with a particular project.

5. Neptune

c.1504–5
Black chalk
251 × 392mm (9⅞ × 15⁷⁄₁₆")
Inscribed upper left by Leonardo *a bassa i chavalli*
RL 12570

This is generally accepted to be a preparatory study for a highly finished drawing described by Giorgio Vasari in his *Life* of Leonardo:

> For his good friend Antonio Segni, [Leonardo] drew a Neptune on a sheet of paper, with so much diligence that it seemed to be alive. The water could be seen churned up, and his chariot drawn by sea-horses, with spectres, sea monsters and south winds, and very fine heads of sea gods. The drawing was given by [Antonio's] son Fabio to Giovanni Gaddi, with this epigram:

> *Pinxit Vergilius Neptunum: Pinxit Homerus*
> *Dum maris undisoni per vada flectit equos.*
> *Mente quidem vates illum conspexit uterque*
> *Vincius ast oculis; jureque vincit eos.*

> [Virgil and Homer both depicted Neptune driving his horses through the rushing waves. The poets saw him in their imaginations, but Vinci with his own eyes, and so he rightly vanquished them.]

Antonio Segni (*c*.1460–1512) had been appointed Master of the Papal Mint on 26 September 1497, though he did not reside permanently at the Vatican and travelled intermittently between Rome and his native city of Florence. He must have been an erudite collector, for Botticelli presented him with his painting the *Calumny of Apelles* (Uffizi), and the friendship between Segni and Leonardo mentioned by Vasari would explain why the artist made such an exceptional drawing for him.

Segni's *Neptune* is lost, and – strangely for a work that was famous during the sixteenth century – we have no certain record of it in a copy drawing or a print. A damaged drawing in the Accademia Carrara, Bergamo (fig. 13) has been claimed as at least a partial copy of Leonardo's design, and this may well be correct, for the horses to the right and Neptune's head and shoulders are very similar to the present drawing. The Bergamo drawing does not include any of the other sea creatures mentioned by Vasari, though the rough head of a dragon-like monster of a type often drawn by Leonardo is clearly visible at the centre left edge of the

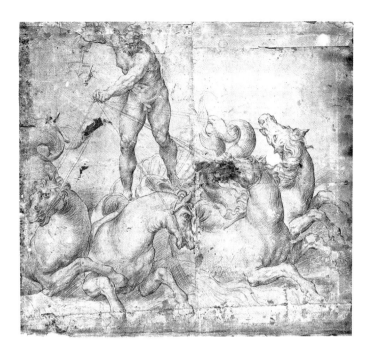

Fig. 13
Presumed copy after Leonardo
Neptune, after 1504
Red chalk
445 × 516mm (17½ × 20⁵⁄₁₆")
Bergamo, Pinacoteca
dell' Accademia Carrara

Windsor sheet. The large size of the Bergamo sheet, 445 × 516mm (17½ × 20⁵⁄₁₆"), is in itself evidence that it is a copy of something out of the ordinary; if this is an accurate reflection of the size of the original, Leonardo's drawing was on the scale of a small painting rather than a normal drawing.

In the Bergamo drawing Neptune stands with the horses at his feet, and indeed the present sketch, in which Neptune is seen from the thighs up, carries Leonardo's rough note to himself 'lower the horses'. With Neptune standing the design is significantly taller than the pronounced elongated oval that is such a distinctive feature of the present sketch, which was probably conceived in the manner of an antique cameo or carved gem. Leonardo cannot, however, have been directly inspired by a cameo of the subject, for the very few that show Neptune driving his chariot are arranged in a profile format rather than the more challenging frontal aspect he has chosen.

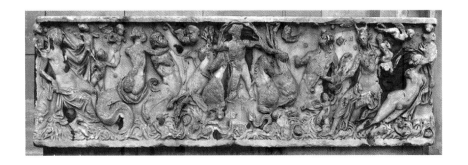

Fig. 14
Roman sarcophagus
Neptune, Nereids and Tritons, 2nd – 3rd century
Marble
Vatican Museums,
Cortile della Pigna

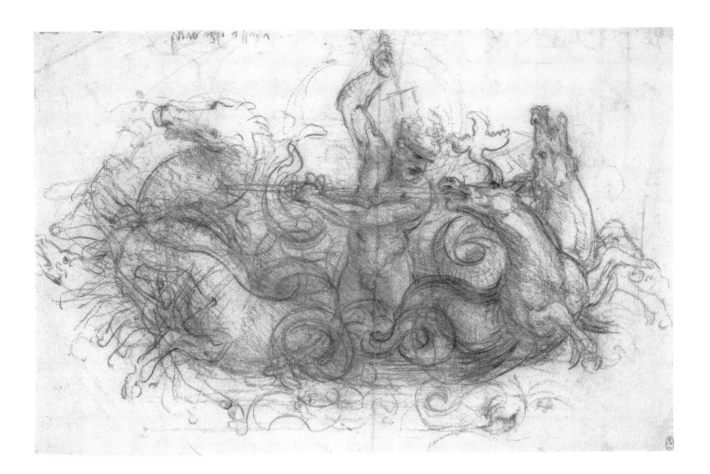

An inspiration for Leonardo's composition may instead have been a relief on a Roman sarcophagus, now in the Vatican, that shows Neptune standing in a low boat drawn by four sea horses placed symmetrically either side of the god (fig. 14). By the end of the fifteenth century the sarcophagus was one of a famous collection at the church of Santa Maria in Aracoeli in the centre of Rome. On grounds of style cat. 5 must date from around 1504, when Leonardo was (among other projects) working on the composition of the *Battle of Anghiari*, which involved a comparable interweaving of man and horse (fig. 6). Leonardo had presumably visited Rome around this time, for in April 1505 he was reimbursed for customs duty on a parcel of his clothes sent from the city. It is thus plausible that the *Neptune* was conceived during that trip, Leonardo having visited his friend Segni and seen the sarcophagus at the Aracoeli.

Highly finished chalk drawings were known in northern Italy in the late fifteenth century, particularly in the circles of Mantegna and the Bellini, but Leonardo appears to have been the first artist to produce such a drawing in central Italy. The *Neptune* must have been very much in Michelangelo's mind when that artist made his magnificent series of 'presentation drawings' in the 1520s and 1530s.

c.1505–7
Red chalk, touches of white chalk, on pale orange-red prepared paper
155 × 162mm (6⅛ × 6⅜")
RL 12419

Around 1505 Leonardo executed a series of drawings of plants. Most were drawn with a finely pointed red chalk on paper coated with a delicate orange-red preparation probably composed of ground red chalk. They are as objective and delicate as any scientific drawing produced during Leonardo's career.

It appears that most, if not all, of these botanical studies were made in connection with a projected painting of *Leda and the Swan*. A myth relates that Leda, the wife of Tyndareus, King of Sparta, was seduced by Jupiter in the form of a swan and bore two eggs, from which hatched Helen of Troy, Clytemnestra, and Castor and Pollux. Leonardo was to emphasise the theme of fertility in his composition by including a foreground burgeoning with plants.

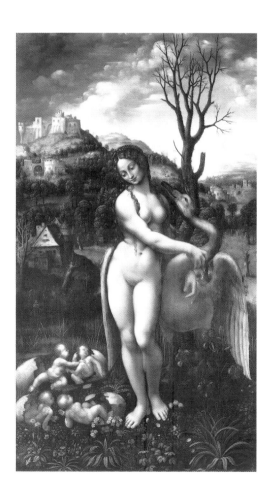

Two fully resolved drawings survive in which Leda kneels while embracing the swan, but Leonardo abandoned this contrived and unstable pose and evolved instead a composition in which Leda stands. A carefully worked drawing in this format was completed by 1508 at the latest, when it was copied by Raphael. Over the next ten years Leonardo executed a painting of the standing Leda, which was the most highly valued item in an inventory of the estate of his assistant Salai after the latter's death in 1524. The painting was seen at Fontainebleau in France in 1625, but its deteriorating condition apparently led to its destruction some time between 1694 and 1775.

Fig. 15
Copy after Leonardo
Leda and the Swan, after 1508
Oil on panel, 131 × 76cm (51½ × 30")
John G. Johnson Collection,
Philadelphia Museum of Art

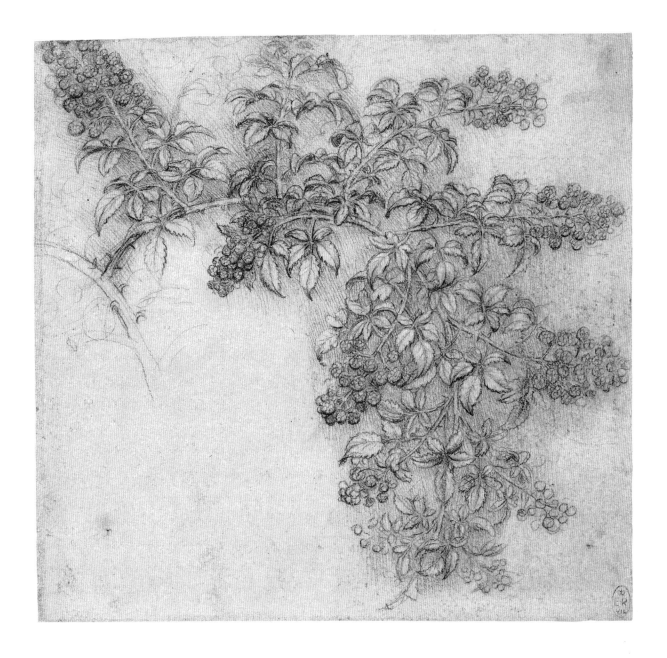

Several painted copies of the composition are known, which agree generally in the forms of Leda and the swan but differ greatly in their surroundings (fig. 15). Plants studied by Leonardo in the botanical series of drawings occur in several different combinations in the painted copies; a blackberry or bramble appears in a version in the Richeton collection, for instance. It is possible that many of the studies were used by Leonardo in his cartoon and painting, while his less assiduous followers selected just a few plants from the original for their own versions.

*c.*1508

Pen and ink, with red chalk

314 × 437mm (12⅜ × 17¼")

Extensively inscribed by Leonardo

RL 19149v-19152v

RL 19152V	RL 19150V
RL 19151V	RL 19149V

One of the many projects that occupied Leonardo throughout his life was the preparation of a treatise on painting. Theories and observations are scattered throughout Leonardo's drawings and notebooks, but – like so much else – he never brought the work to completion. The years around 1508 saw Leonardo's most sustained work on light and optics, and this sheet is one of the most comprehensive to have survived, expounding his theories of the propagation of light and the casting of shadows.

The ghostly red chalk study of a stooping man is by a pupil rather than by Leonardo himself; it was presumably the first drawing to be made, and Leonardo simply covered the study with his own notes rather than wasting a good sheet of paper. The sheet was folded twice by Leonardo before he began to work on it, and he compiled the notes and diagrams on both sides in orientations such that, if the page were folded back into quarto form, all the notes would be the right way up. In its present unfolded form, the notes on one half of the sheet are inverted with respect to those on the other.

The small sketches showing a man in the act of striking the ground with a hammer, to the lower right of centre, are accompanied by the portentous title *De pictura* (On Painting), which might suggest that they were the first to be drawn by Leonardo. Most of the notes in that quadrant (RL 19149v) discuss five shadow areas cast by a sphere illuminated by two extended light sources, varying in density depending both on the degree of obscuration of one or both sources and on the distance from those sources.

The page at upper right (RL 19150v) first examines the hypothesis that light rays from an object are propagated in all directions. Leonardo followed his medieval predecessors in conceiving of light as propagated images of the object, and he variously used the words *similitudine*, *simolacro* and *spetie* to express this concept. To demonstrate the idea Leonardo drew a *camera obscura* (the long shaded box), with two apertures, and added the note:

> The images of objects are diffused throughout the atmosphere which receives them, all of them in every part of it. To prove this, let *a c e* be objects of which the images are admitted to a dark chamber by the small holes *n p* and thrown upon the plane *f i* opposite to these holes. As many images will be produced in the chamber on the plane as the number of the said holes.

Most of the other notes on that page, and those on the otherwise inconsequential page at upper left (RL 19152v) on the passage of light through a small aperture, discuss the observation that images propagate in straight lines without interfering with one another. Leonardo had observed diffraction in water waves, but he was of course unaware of the wave properties of light and the similar effects of diffraction through a very small aperture.

The remaining diagrams at upper right concern the optics of the eye, incorporating a piece of faulty physiology. Leonardo assumed that the image perceived within the eye would be upright, but he knew that as light passed through the pupil the image would be inverted (as it indeed is when it falls on the retina). He therefore postulated that refraction through the lens would again invert and thus 'correct' the image.

The page at lower left (RL 19151v) examines the phenomenon of coloured shadows. A sphere is lit by two sources, a red light and a blue light. Leonardo explains:

> The colours of derived shadows always partake of the colours of the bodies which illuminate them. To prove this, let an opaque body be interposed between the wall and the lights, blue and red. The blue light sees all the wall except that which the shadow of the opaque body occupies, and the same happens to the [red] light…
> The shadow being caused by the blue light is red, and the shadow cast by the red light is blue.

As a painter Leonardo was greatly interested in the colours of cast shadows; he wrote elsewhere that 'the surface of every body takes on the colour of its source', including not only light sources but also adjacent coloured objects. 'The lit colour of faces, having opposite them an object of black colour, will acquire black shadows, and this will happen correspondingly with yellow, green, blue, and every other colour placed opposite it.' 'Shadows generated by the redness of the sun close to the horizon will generally be blue.' 'I once saw green shadows made by the ropes, masts and yards [of boats] on the surface of a white wall when the sun was setting, because those parts of the surface of this wall which were not coloured by the light of the sun were coloured by the hue of the sea.' These theories of reflected hues and coloured shadows might have been of great importance to painters, but were not put into practice consistently until the nineteenth century (and then, of course, independently of Leonardo).

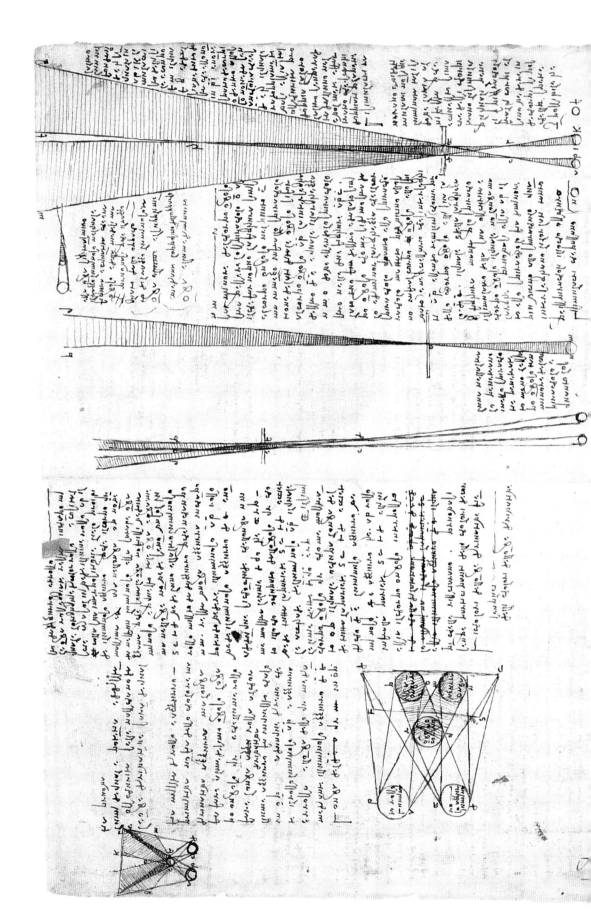

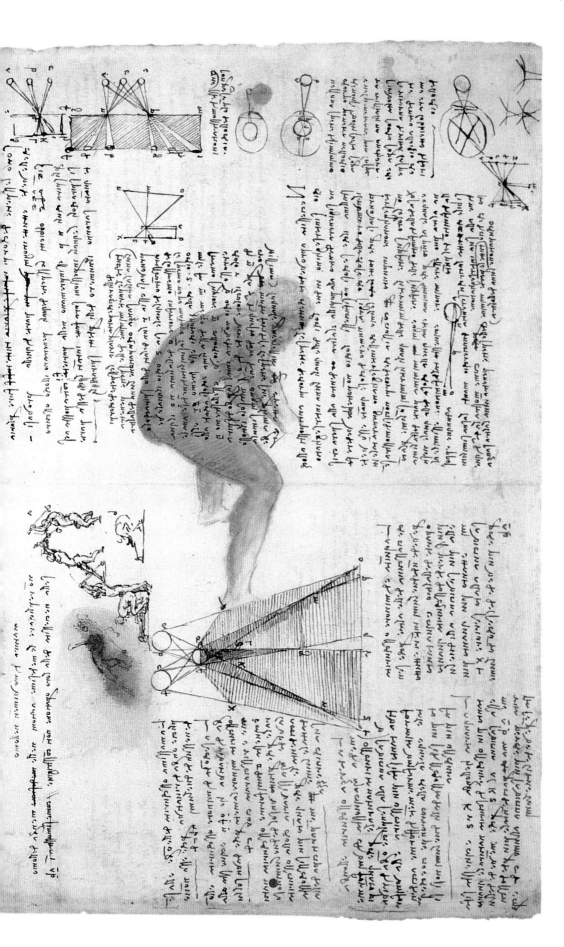

*c.*1510
Red and black chalks on red prepared paper
217 × 153mm (8⅜ × 6")
Inscribed lower left 34.
RL 12554

The profile held a peculiar fascination for Leonardo. In sheets from all periods of his career, sketches of two standard types in profile, a gnarled old man and an angelic youth, are found with almost tedious frequency. Both types seem to have been appropriated by Leonardo when he was working with Verrocchio in Florence, and either profile would spring readily to Leonardo's pen in an idle moment. Since he was left-handed, his profiles usually face to the right, for a draftsman naturally constructs a profile with his hand 'inside' the face.

Like all artists, Leonardo doubtless used friends and assistants as impromptu models, and heads of the present type were once thought to be portraits of Gian Giacomo Caprotti, known as Salai, who entered Leonardo's workshop in 1490 aged ten. In the literal sense of portraiture this notion cannot be sustained, but at a deeper level it may have some substance. Until about 1490 Leonardo's youths usually have shoulder-length hair, waving towards the ends; after this date most have quite tight curls. Salai was described by Vasari as 'having beautiful curly hair, in which Leonardo took great delight', and a generation later Giovanni Paolo Lomazzo wrote explicitly of the homosexual nature of the relationship between Salai and Leonardo. Salai had a troublesome character – Leonardo's first note on the boy records his bad behaviour and calls him 'liar, thief, stubborn, glutton' – and he never became more than an indifferent painter, but he stayed with Leonardo until the end of the artist's life twenty-nine years later. It is surely not fanciful to imagine Leonardo's ideal of youthful beauty being transformed by the entry of Salai into his life. This drawing and many others of the same type were made not as studies for paintings but as finished works for Leonardo's own pleasure.

Leonardo had occasionally drawn in red chalk on red prepared paper since the mid-1490s. It was usual to tint the coating of a paper prepared for metalpoint drawing, and in his youth Leonardo had employed some vivid orange, blue and purple grounds, but a prepared ground was not necessary for chalk drawing. Leonardo's use of red prepared paper for red chalk drawings can be ascribed only to an interest in the colouristic and tonal effects of the combination. It was to become one of Leonardo's favourite techniques after 1500, often with the addition of black (as here) or white chalks. His development of the technique reached its (sometimes illegible) conclusion in a group of drawings from Leonardo's last years that were executed in black chalk on dark grey prepared paper.

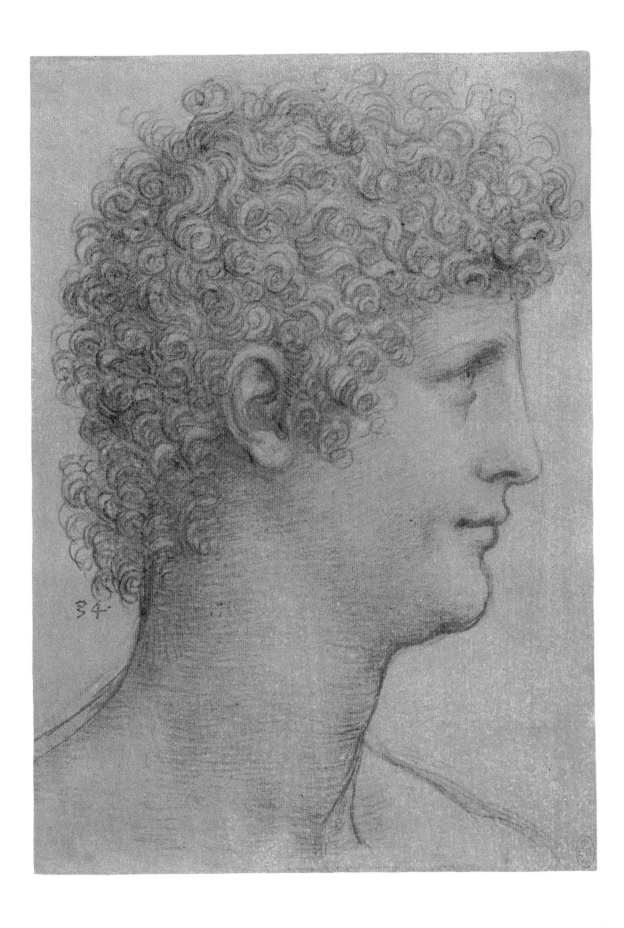

*c.*1510–11
Black chalk underdrawing, pen and ink, touches of wash
291 × 203mm (11⁷⁄₁₆ × 8")
Extensively inscribed by Leonardo
RL 19003v

While a grounding in human anatomy was a commonplace in the training of Renaissance artists, Leonardo was one of the few to conduct dissections himself. He first became seriously interested in the subject in the late 1480s, making a number of drawings based on animal dissection, human skeletal material (fig. 5) and received wisdom, and outlining a plan for a treatise on the subject. These studies lapsed until around 1505, when Leonardo returned to the subject in the wake of his work on the mural of the *Battle of Anghiari*. He now had some access to corpses in the monastery and university hospitals, for properly regulated dissection was not forbidden by the Church, as is commonly supposed. In a famous note of 1508 Leonardo described witnessing the demise of a man who claimed to be over a hundred years old, and conducting an autopsy 'to see the cause of so sweet a death'.

Leonardo's finest anatomical work was carried out around 1510, when he was reportedly working in collaboration with Marcantonio della Torre (*c.*1478–1511), the professor of anatomy at the university of Pavia, about thirty kilometres or twenty miles south of Milan. Marcantonio was one of a handful of anatomists in northern Italy responsible for the revival of interest in the work of the Græco-Roman physician Galen, many of whose writings had survived from antiquity. Marcantonio's position allowed Leonardo greater access to human material: the number of dissections he claimed to have carried out increased from 'more than ten' around 1509 to 'more than thirty' towards the end of his life, and this is not contradicted by the number of surviving drawings. The present sheet comes from a uniform series of folios (all now at Windsor) with osteological and myological drawings (bone and muscle studies) on both sides of the sheet; these were probably compiled in the winter of 1510–11 in association with Marcantonio.

Many of the drawings show the specimen as if still alive, a convention for anatomical illustration throughout the Renaissance and beyond. In the first drawing, at upper centre, Leonardo shows pectoralis major (the superficial chest muscle) divided into sections to reveal pectoralis minor (the deeper muscle) running up beneath it to the clavicle (collar-bone). He states that, in the act of breathing, pectoralis minor pulls the angle of the ribs upwards, thus expanding the chest cavity.

To the right of this is one of Leonardo's most ambitious thread-diagrams (see detail over-

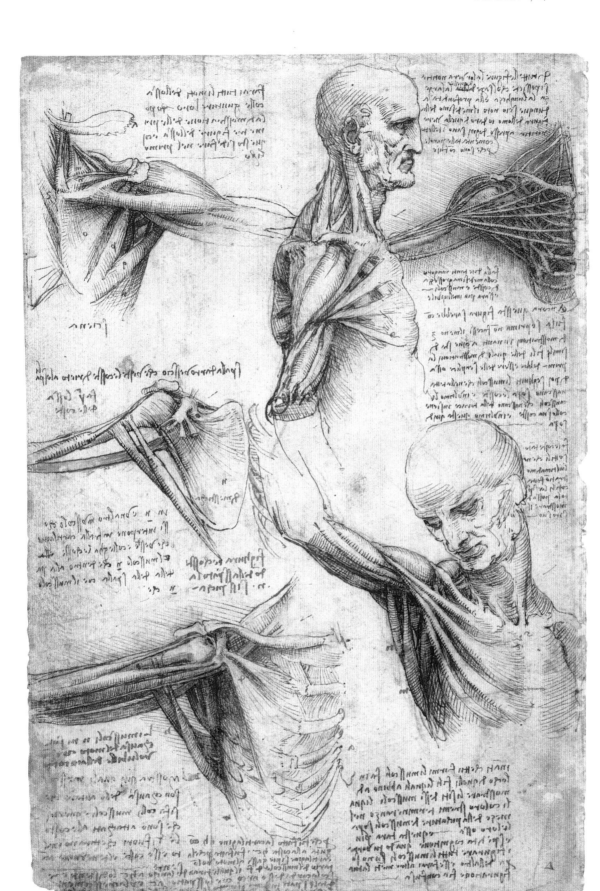

leaf), an attempt to depict a complete system in one drawing by reducing the muscles to single cords along their central lines of force. The paragraph immediately below it (which, like many of the notes surrounding Leonardo's drawings at this time, is about methods of representation rather than directly about the anatomy) details how Leonardo wished to compile a series of diagrams, gradually increasing the complexity of the system shown:

> This figure will be confused if you do not make at least three diagrams before this with similar threads. The first of these diagrams should be of the bones alone; then follow with the muscles which within the chest arise on the ribs, and then the muscles which arise from the thorax as a whole with its ribs; and finally this [figure] here, above. Make the ribs so thin that in the final diagram with threads the scapula can be shown in position.

At upper left is a posterior view of the shoulder with trapezius (the muscle running from the neck across the top of the shoulder) detached to show its point of insertion. Below this we have an anterior view of the shoulder with pectoralis minor and coracobrachialis (from the clavicle down the arm) cut away to show subscapularis, the deep muscle between the scapula and the ribs. This diagram and the two below also show prominently the muscles teres major and latissimus dorsi, running from the side of the back to the upper arm, to demonstrate their responsibility for the rotation of the arm.

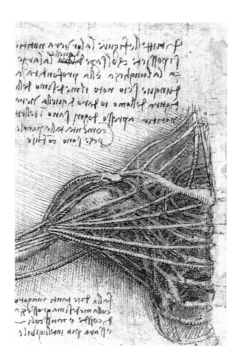

Detail of cat. 9

10. A tempest

*c.*1510–15

Black chalk, pen and ink, brown wash, touches of white bodycolour

270 × 408mm (10⅝ × 16⅛"), lower left corner cut

Inscribed lower centre *107*

RL 12376

A vast storm destroys a landscape. Among the dense clouds raging in from the left can be seen wind gods blowing trumpets; one of these parts the clouds at upper centre. Below, the land is wrecked, and a massive landslide peels away from the remains of a mountain at upper right, falling into the waters that rush around its base. At lower right the tempest has overwhelmed a party of horsemen who cower on the ground as broken trees fall among them (see detail on page 4).

The depiction of cataclysmic storms was one of Leonardo's favourite subjects during the last decade of his life, in both his drawings and his writings. There exist several long passages in which he recounts with relish the futile struggles of man and animal against the overwhelming forces of nature and, though there is no direct illustrative relationship between drawing and description, many elements recur frequently in both:

> To represent the storm accurately you must first show the clouds scattered and torn and flying with the wind, accompanied by clouds of sand blown up from the seashore, and boughs and leaves swept along by the strength and fury of the blast…
> Trees and plants must be bent to the ground, almost as if they would follow the course of the gale, with their branches twisted out of their natural growth and their leaves tossed and turned about. Of the men who are there some must have fallen to the ground and be entangled in their garments, and hardly to be recognised for the dust, while those who remain standing may be behind some tree, with their arms around it that the wind may not tear them away; others with their hand over their eyes for the dust, bending to the ground with their clothes and hair streaming in the wind. (Paris, Bibliothèque National, MS 2038, f. 21a)

> Let there be represented the summit of a rugged mountain with valleys surrounding its base, and on its sides let the surface of the soil seem to slide, together with the small roots of the bushes, denuding great portions of the surrounding rocks … and let the mountains as they are laid bare reveal the deep fissures made in them by ancient earthquakes … And into the depth of some valley may have fallen the fragments of a mountain, forming a shore to the swollen waters of its river, which, having already

> burst its banks, will rush on in monstrous waves; and the greatest will strike upon
> and destroy the walls of the cities and farmhouses in the valley. (RL 12665r)

The beginnings of each of these passages indicate that they were conceived in the context of Leonardo's intended treatise on painting. The aim of much of the treatise was to expound the scientific basis of painting, and sometimes the descriptions of cataclysms digress into simple dynamics:

> And if the masses of the vast ruins of huge mountains or of grand buildings fall into
> the great pools of water, a great quantity of the water will rebound in the air and its
> course will be in a contrary direction to that of the object which struck the water: that
> is, the angle of reflection will be equal to the angle of incidence. (RL 12665r)

The depiction of atmosphere in works such as the *Madonna and Child with St Anne and a lamb* (fig. 7) and the *Mona Lisa* (both Louvre) was one of Leonardo's finest achievements as a painter. Here, and in many other late drawings in ink and chalk alone, Leonardo attempted to capture the optical qualities of cloud, rain, water, debris, dust and smoke, all swept up in great layers of overlapping vortices. These drawings cannot have had any preparatory function and, like many other sheets from throughout Leonardo's career, were no doubt drawn for his own pleasure.

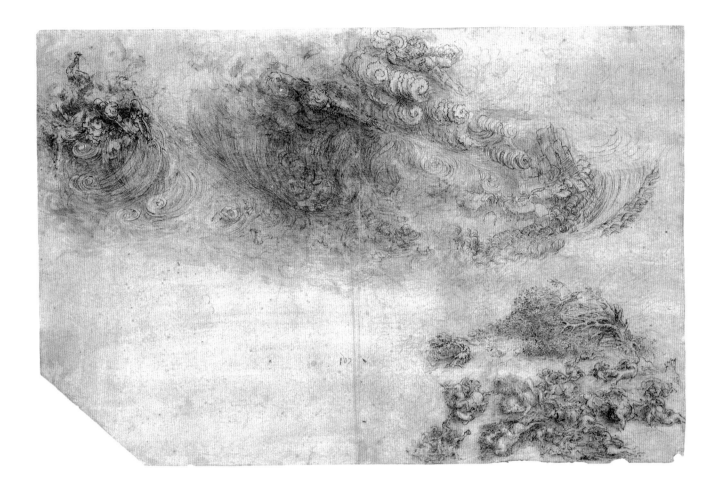

Further reading

The literature on Leonardo is immense, and the following list contains only a handful of the more satisfactory and readily available books on the artist, with an emphasis on works concentrating on Leonardo's drawings:

K. CLARK, *Leonardo da Vinci, An Account of his Development as an Artist*, Harmondsworth/Penguin, London, 1989

K. CLARK AND C. PEDRETTI, *The Drawings of Leonardo da Vinci in the Collection of Her Majesty The Queen at Windsor Castle*, 3 vols, Phaidon, London, 1968–9

M. CLAYTON, *Leonardo da Vinci: A Curious Vision*, exh. cat., The Queen's Gallery, London, 1996

C. GOULD, *Leonardo, The Artist and the Non-Artist*, Weidenfeld and Nicolson, London, 1975

M. KEMP, *Leonardo da Vinci, The Marvellous Works of Nature and Man*, J.M. Dent and Sons Ltd, London, 1981

M. KEMP, J. ROBERTS et al., *Leonardo da Vinci*, exh. cat., Hayward Gallery, London, 1989

M. KEMP AND M. WALKER, ed. and trans., *Leonardo on Painting*, Yale University Press, New Haven and London, 1989

P. MARANI, *Leonardo da Vinci: The Complete Paintings*, Harry N. Abrams Inc., New York, 2000

C.D. O'MALLEY AND J. SAUNDERS, *Leonardo da Vinci on the Human Body*, Dover, New York, 1983

C. PEDRETTI, *Leonardo da Vinci: Nature Studies from the Royal Library at Windsor Castle*, exh. cat., Royal Academy, London, etc., 1981

—— *Leonardo da Vinci: Studies for the Last Supper from the Royal Library at Windsor Castle*, exh. cat., Santa Maria delle Grazie, Milan etc., 1983

—— *Leonardo da Vinci: Drawings of Horses from the Royal Library at Windsor Castle*, exh. cat., Palazzo Vecchio, Florence, etc., 1984

A.E. POPHAM, *The Drawings of Leonardo da Vinci*, Pimlico, London, 1994

J.P. RICHTER, *The Literary Works of Leonardo da Vinci*, 2nd edn, 2 vols, Oxford University Press, 1939 (which should be read in conjunction with C. Pedretti, *The Literary Works of Leonardo da Vinci: A Commentary to Jean Paul Richter's Edition*, Phaidon, Oxford, 1977)

GIORGIO VASARI, *Lives of the Artists* (ed. and trans. George Bull), Penguin, London, 1987 (vol. 1)